A POTTER'S NOTES
ON
TAI CHI CHUAN

ALSO BY MARGARET EMERSON

Eyes of the Mirror
Artichoke Press, Bayside CA

Breathing Underwater: The Inner Life of T'ai Chi Ch'uan
North Atlantic Books, Berkeley CA

T'ai Chi: Wu Style Long Form (videotape or DVD)
Artichoke Press, Bayside CA

MARGARET EMERSON WEBSITE

www.MARGARETEMERSON.com

CONTACT THE AUTHOR BY E-MAIL

memerson@humboldt1.com

A POTTER'S NOTES
ON
TAI CHI CHUAN

Margy Emerson

ARTICHOKE PRESS
BAYSIDE, CALIFORNIA

A POTTER'S NOTES ON TAI CHI CHUAN

Published by
Artichoke Press
P.O. Box 16
Bayside, California 95524

Drawings by Margy Emerson
Cover photographs by Bob Pottberg

Library of Congress Cataloging-in-Publication Data

Emerson, Margaret Jane, 1948—

A Potter's Notes on Tai Chi Chuan/Margy Emerson

ISBN 0-9620690-0-0

1. Martial Arts 2. Art 3. Personal Growth

Library of Congress Control Number 2005910751

Whether to write about Tai Chi Chuan

Any knowledge of this subject is "common knowledge", accessible to everyone and ultimately self-taught. There are no secrets.

All that's needed is to practice it consistently for years.

For those not interested in practicing, no amount of reading, study, or research will bring them closer to the essence and benefits of Tai Chi Chuan. This is not knowledge to be learned in the Western sense, and will elude all the "straight A" students. It is better named awareness than knowledge since knowledge can be memorized without experiencing it, and awareness can only be gained through experience.

So here is the dilemma: writing about the nature of Tai Chi Chuan isn't useful or comprehensible to those who don't practice it, and it's superfluous to those who do.

Still there is a need to express and to share. And perhaps inspire others.

I couldn't help but notice the many ways in which my experience with clay and with Tai Chi Chuan mirrored each other. Light ricocheted back and forth so that both were better illuminated. The clay brought my growing awareness into con-crete terms, where it indeed belongs.

Anyone who has worked intimately and lovingly with any medium has shared this experience and contains this awareness. This writing, whether they are potters or not, whether they practice Tai Chi Chuan or not, speaks to them.

Why a potter feels at home with Tai Chi Chuan

I was drawn to Tai Chi Chuan because I knew it would suit me. In order to work well, all of me has to be working together: my mind, my body, my spirit. I looked for a form of meditation that would allow all of me simultaneous expression.

My intellect was used for learning the movements and memorizing the sequence. The basic vocabulary of Tai Chi Chuan is, to an American, a foreign language: a new way of standing, of breathing, of regarding strength. Now my mind is busy digesting and naming the observations made during practice. Each time I perform the sequence my mind works in concert with every other aspect of my self to center on the sequence—both visible and invisible parts.

The continuous motion draws all of the body—inner organs and outer limbs—into a series of gestures that stretch and exert. A soothing and invigorating experience.

The wavelike sequence is a dance that reaches down in and gently invites the spirit to merge—not only with its physical partner, but also with the infinite pool of energy that surrounds and pervades everything. The spirit is unveiled, harmonized with the body and the life force.

I was drawn to clay while in school. Writing papers, memorizing for tests, my body felt lethargic and I yearned to see tangible results of my work. Writing about art seemed a meaningless exercise. I wanted to make something, to do work that stimulated me on every level.

Working with clay and glazes and kilns can be as technical as a potter chooses to make it, but this is not the only way intellect enters in. I have to manage the financial realities of being in the business of selling my own art—well enough to make a living. I have to fulfill unique commissions, invent ways of making things I have never seen made before, reconcile beauty with function, and deal with every person who walks into my shop.

The physical demands of being a potter are great— overwhelming at times. It's heavy, grubby work that keeps me humble (even looking humble). The firing is both tense and intense, a climax to all the work—technical, physical,

creative. The making of pottery demands good health, coordination, strength, dexterity. In the best of times the labor becomes so integrated with everything else that the work flows from my hands without conscious effort.

Creative energy is the will of the spirit to be expressed. In pottery that expression is on a purely abstract level. Without words yet far from mute. I believe there is a secret alive within my potter's wheel. The turning, turning, the repeating of my own designs by holding within myself the characteristic feeling of a particular shape each time it's made is a form of meditation. Quiet is achieved, and through the wheel the spirit speaks. The potter's wheel is a medium.

Art is the tangible manifestation of an unseen vision perceived without eyes and revealed first to the artist, then perhaps shared with others. The making evokes all parts, all levels of the artist, as Tai Chi Chuan evokes the whole person.

Morning

Day after day, morning to morning, the pattern is repeated. A rhythm is formed, a routine chosen. To flow gracefully, peacefully, solidly before the rest of the day crowds in: a gift to myself.

As the body moves, so moves the soul. Drawn into the even, tranquil movements, it experiences the hard and soft, strong and gentle just as the body does. An exercise for the soul.

Preparation: an ordering and gathering of all one's forces. The upcoming tasks are clearer; their jagged edges dissolve into smooth curves.

Thirteen miles of asphalt country roads past fields and farmhouses. Always the season told in the landscape—from the tinge of green hovering over the black soil in spring to the dry white powder whipping across frozen drifts in the January wind. I drive from my Illinois home to my studio, full of anticipation, plans, images. Twenty minutes to gather myself, to become ready for work. By the time I arrive, I've accumulated momentum that takes me a long way.

I value my routine—my country drive, my organized shop, clean surfaces and tools. It frees me to concentrate on one thing. It clears a space in which I can create.

Learning

Tai Chi Chuan begins with a teacher. It cannot be transmitted through printed words and illustrations. One body informs another. The teacher brings you to and helps you through a period of newness and confusion, through layers of technique and meaning that go deeper with every lesson.

The movements are repeated again and again, at first instructed by the intellect. Gradually the pattern is implanted in the body, is "incorporated" and resides there.

Then the self-teaching begins. The movements are symbols that slowly expand from two dimensions to three, absorbing meaning and power that penetrate and blend with the core of the practicer. The student transcends the teacher, needing only the movements themselves to act as a conductor of the life force. Little by little, over the course of a lifetime, its gifts are imparted.

Self-taught or taught by others, an artist begins by getting to know the chosen medium, finding out what it can and cannot do, acquiring skill.

Some become infatuated with technique and never go beyond this stage. A shallow and superficial approach to art, it thwarts the expression of the subconscious.

An artist quickly transcends technique or ceases to be an artist.

I had been working very hard for a long time but was not nearly done. Out of sheer exhaustion my mind shut down as if a switch had been thrown. Yet my hands went on making as if all intelligence and will and motivation lived in them. The work was good. Like the wizard boasting of powers he didn't have, my mind was exposed as only pretending to be in control. Everything I knew was in my hands.

A POTTER'S NOTES .

Gathering

Palms reach outward and I embrace a glowing ball of light, gather it in. My fingertips, the insides of my arms, my chest, and all my torso receive the countless delicate white strands that emanate from the sun rising in the east—a sun that is always rising, never blocked by clouds or walls or night.

I am at once soothed and empowered. The presence of this light invests me with peace, health, and strength. It leaves no room for physical or spiritual poisons. They are given off as mist rises from frosted boxwood at the first touch of morning sun.

At all times we exist in a pool of life-energy that surrounds and pervades us, whose currents we can attract, consolidate, and direct. During the sequence I can feel this like moving water, languid or cascading, responding to every movement of every part of my body, forming graceful swirls and eddies as I shift and turn.

I become the lightning rod, the tornado's target, the center of the vortex itself.

An artist's concentration: drawing on diffuse and motley sources, distilling them into a single object. As a magnifying glass concentrates sunlight: magnificent power. All physical, mental, spiritual experiences are used.

My hours, my years with clay are making me a stronger medium, a more able gatherer and channeller of the creative force.

Silence

"This is not a time for daydreaming," Madelaine said. (My teacher with the Chinese accent and the French name.) Just the same, thoughts creep in: the insurance payment, yesterday's argument, the art show deadline a week from today. But there are also spaces, sometimes prolonged, when I seem to slip into a deep hole with nothing in it. No thoughts. No images. Only a wavelike sensation saturating me, surrounding me.

Sometimes I deliberately envision waterfalls or yards of feather-light silk billowing, curving back on itself as extensions of my movements. They are pleasurable images and harmonize nicely with the sequence. But, more and more, I descend into silence.

At first it surprised and confused me. I'd cling to the edge of the precipice and think: shouldn't I be thinking? Shouldn't my thoughts be headed somewhere? Where is this taking me? No landmarks. Only a vibration—long, slow, smooth waves that are experienced, not seen or heard or even felt in the usual way.

And that's when the center is touched. That's where it all comes from.

I like to start out with only clay. No ideas. No fancy tools. No expectations. Just my hands and a big piece of well-wedged, well-aged clay with some life in it. I used to call it stream-of-consciousness working. Now I think of it as stream-of-subconsciousness. If I'm lucky, that's what it is. Start with a tabula rasa and let the oracle within me and the clay speak.

It all starts with the silence of not thinking, not anticipating. Yet I always have a feeling of excitement when I do this. I know something will be revealed, will take shape through the clay. Something new. I surprise myself.

Three points, eight directions

Nose, toes, fingertips: the three points of Tai Chi Chuan face one of the eight directions. Each direction will be addressed in turn as if it were the only one. And in this I discover the key to solidity and balance.

Focus: to the temporary exclusion of all else. One task, one goal, as if none others existed before or after or simultaneously. Even while making a set of bowls or mugs or plates on the wheel, each one must be given the attention of a one-of-a-kind piece. Otherwise the effect of each piece by itself and of the set is diluted, blurred.

This approach of focusing allows me to do the best work I can. All peripheral obstacles vanish.

Important decisions are always preceeded by what feels like an orienting of all parts of myself toward a certain resolution: iron filings aligning themselves toward a magnet.

Nose, toes, fingertips: when all of me points in one direction, I move with strength and ease.

The secret of balance

Is knowing where I am and being only there.

In time and space: not ahead or behind.

The sequence shows me this each morning and slowly the lesson spreads into my work, spills over into my life.

Balance from one day to the next

Like a cat stalking a bird, paws lifting silently in slow motion, then returning to the earth with perfect delicacy, so the feet of Tai Chi Chuan move. No wobbling indecision. Weight shifts surely like water poured from one vase to another until one is empty and the other full. Finally being all in one place at one time.

On a good day, anyway—an "on" day when every step is sure, and the leg lifts are performed with ease. In the midst of a very stressful period I'm likely to be rock solid as if my whole self is responding to the challenge. After the difficult time is over, I'll be unsteady for a few days while inwardly and outwardly recuperating. Alcohol and over-exerting myself physically put me off. But I can't always anticipate when I'll have "on" days and when I'll have "off" days. Either may come when I least expect it.

In my studio, an "on" day is a day when everything works, all my skills are coordinated, the clay seems alive. My touch is light and confident and effective. An "off" day means I'm clumsy, both physically and mentally. The clay is uncooperative and we are not connected.

Which sort of day any given day will be is not predictable by the obvious factors alone—weather, turmoil or serenity in my personal life, even my health. Some hidden element is there which can override almost anything. In the face of the greatest odds, I might experience an incredibly productive and creative day. When all the circumstances seem right, that may be the day when nothing works.

Outward balance mirrors an inner state otherwise unseen.

Living balance

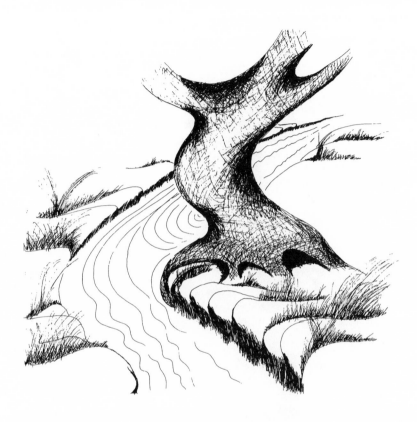

A tree balances itself on the bank of a stream, its home. Upper form adjusts, roots below adapt as water sculpts earth in unforeseeable shapes at unforeseeable rates. The tree responds, like a partner in a dance, to the movement of the stream and influences that movement. Through years of change the tree survives, thrives, grows.

The practicer of Tai Chi Chuan mirrors this phenomenon of moving balance. Nothing stays the same, yet balance remains.

A potter is in balance with the clay—both elements in constant flux. The potter suggests and the clay responds. The clay suggests and the potter responds.

Preconceived ideas of how the pot should look may have to be sacrificed as the clay is drawn into the dialogue. From the two comes something spontaneous and unselfconsciously unique.

> I had spent the whole day trying to make the clay form a wallhanging that was worth keeping. In the late afternoon I walked away from the work table in frustration. Looking back at the lifeless piece I noticed the scraps to the left: there was my wallhanging. It needed only minor contributions from me to become one of my best.

Living work has no acquaintance with rigidity.

Reserving

Tai Chi Chuan is a gentle art. Elasticity and flexibility are cultivated. Stiffness and rigidity are avoided. Limbs are never fully extended, joints are never locked. Nothing obstructs the circling of the blood, of the life force, through the body.

Never is anything forced, taken to its furthest limit or to its breaking point. The boundaries of one's limitations are gently moved further and further away without ever touching them.

Tai Chi Chuan teaches gentleness and kindness to oneself, and therefore to others. It is not a form of penance or a superficial testing of potential. Tai Chi Chuan is not a bully.

Because of this reserving, this returning before the furthest point is reached, the sequence creates energy at the same time that it uses it. The flow is continuous and self-renewing. The practicer feels refreshed, not drained and depleted.

I used to work to the point of exhaustion—otherwise I didn't feel I'd worked a full day. Often I couldn't recover completely before the start of the next. So the process of depletion began.

New ideas became less plentiful, old ideas were overworked. Repetition became the mechanical reproduction of measurements instead of the intuitive remaking of shapes. The quality of my work declined and my interest lagged.

I learned to be kinder to myself, to leave some water in the well at the end of the day so that it could replenish itself overnight. I learned to stop working while I still had the desire to work.

Total exertion comes from a fear of shortage, of limitations. The boundaries always have to be tested, to be forced. True potential cannot be approached this way. If it is, limits are met prematurely.

Reserving power comes from confidence and self-love—from a belief that there really are no limits.

Resonating

Arms spread, palms reach, and the infinite life source is welcomed in. Tai Chi Chuan invites the combining of atmospheres, harmonizing that inside the person with the surrounding currents.

The flow, the pace, the timing of the life force—both within and without—vary unceasingly. Each day a new union is made, a new song is created from new elements. Tai Chi Chuan is the resonating of the entire self with the pulse of the life force.

There is no strain in practicing daily—resonating is a very pleasant sensation.

This much I know: each of us shares a common makeup with certain other things, tangible and intangible, animate and inanimate, that reside with us in this world. This commonality gives us, to varying depths, an immediate recognition and understanding of the other person or substance or field. We feel "at home" with it. It's pleasing, healthful, and uplifting to be close to it. If we are given the opportunity to create something out of this phenomenon, people call us "talented".

Some of us are multi-talented, some talented in only one area, some in areas ignored and undervalued by the society they have been born into, and some never have a chance to discover or implement their talent.

And there is dissonance too. Just as my hands feel the pull of clay as if it were a magnet, so do the insides of my palms cringe from contact with hard, brittle materials like steel. Some unfortunate people may sense this dissonance, this lack of harmony, with their entire surroundings. How could they be anything but destructive, full as they must be of the anger and resentment of the "homeless".

Life is easier for talented people who get to use their talent. They are not exempt from work—they are driven to work much harder than most because the rewards are so abundant. They live in accord with at least a part of their surroundings and are not always at crosscurrents with everything or everyone else. They experience the sensation of having a home, having roots and a source of security through their talent. My love for clay has given me direction and sureness and a treasured peace that many of my friends have lacked. I resonate with clay.

Contrast

From the fierce strength of "Leopard and Tiger Push the Mountain" to the fluid serenity of "Reaching Palms of Tai Chi Chuan", from "Dashing Wild Horse"to "Gracious Lady's Golden Hands", the differences that pulsate within us take physical shape and emphasize each other by their contrast. Strong then gentle: the movements alternate, pass through stages, express the range of human experience and response. Nothing denied, nothing judged, everthing reflected in the deep white mirror of the dance.

It was this sort of richness of personality that attracted me to clay. Its plasticity, its ability to assume any shape or texture. Then the fun of putting rough against smooth, simple against complex, color against neutrality, dark against light, round against flat, shiny against matt. It allows me to express my love of change and variation, not just within a single piece but also from one piece to the next, from one phase to the next, from one year to the next.

Each quality becomes more itself through the existence of its mirror image, its reverse, nearby.

Inward-outward

Practicing the sequence is a solitary thing. Drawing the focus inward to a person's own body, mind, and spirit. Over time, this orientation toward the self brings strength that frees one to look outward, to focus effectively on people and events beyond the self.

Without this inner fortitude, people remain self-absorbed, expending all their energy defending themselves against real or imagined slights. There is no room in them for caring about what exists outside except as it effects them.

Tai Chi Chuan is a way of nourishing the inner self, releasing it to attend to outward concerns.

"Handbuilding": a potter's term referring to making something without the wheel. My years spent with clay have been the handbuilding of myself. These years filled with struggle, mistakes, gratification have been an introspective period, a time for slowly discovering and constructing myself.

As I've learned to be attentive to the clay, I've learned to turn this same sort of regard toward myself and then, naturally, toward others.

Concentrating inward prepares one for looking outward.

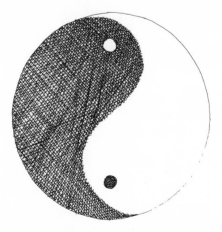

The resolution of a paradox: two things which seem to be opposites prove to be inseparable parts of the same whole.

Hard in soft

Tai Chi Chuan looks soft, fluid, water-like on the outside. But like water it carries within it the potential for immense power.

Over time, the sequence opens all the gates within a person so that the life current flows freely through the entire self—through mind and body and spirit. And so is always accessible, can be directed and funnelled into any chosen task. All this energy will fall as water falls downhill into whatever is focused on by the whole person.

Still the surface is calm, flexible, belying the capacity within.

Clay possesses the same liquid quality. In the wet and workable stage, clay is soft, elastic, responsive. The surface shines sensually, reflects light and holds shadows.

Through the drying and firing the clay hardens to stone yet the surface echoes the forming process. Undulating waves of throw marks or folds remain. Glazes replace the satiny sheen of water.

The outward appearance is preserved, inviting touch, and the interior ready for use.

Visible and invisible

Mary Lou asked me to show her Tai Chi Chuan, so I demonstrated in our mother's back yard while she sat close by on the summer grass. When I finished, she told me she could feel movement in the space around us, a current in the air synchronized with my body. More than just the limbs moving.

Invisible effect stirred by the visible and in turn exerting itself. Felt but not seen by both practicer and observer.

And inside me another invisible: organs respond to the sequence, are exercised and gently massaged.

The outer shell is only one dimension of a multi-dimensional experience that ranges from visible to invisible.

Frequently amazed at how well people have responded to my work, I've wondered about a hidden element—something of myself, my person residing in the clay, surviving even the blast of flames. And thought maybe this something spoke silently to people about how much I enjoy my work and care about the quality of every curve and make every choice from the inside. When they have chosen my work over more familiar, more established or more spectacular work, I've thought they must have been sensing something invisible in the clay that came to it through my hands.

As Tai Chi Chuan has visible and invisible parts, so does work that comes from the heart. People recognize and respond to both.

Coming full circle

The sequence is a series of circles, each one complete in itself before opening to the next. Never is a circle abbreviated—cut off before the end meets the beginning.

No hurry.
Forward and back.
Out and in.

Each circle exists as if it were the only one.

Every piece produced in clay is its own full circle. Every pot tells the potter when it is done.

Hurried by deadlines, distracted by the next task or the previous, a potter may bring a pot to a premature end—a pretend end. Being signed and fired and displayed on a shelf doesn't make a pot finished.

The potter feels its lack of completion just as it's possible to feel its wholeness.

Slowing down

Slow motion: not the way we're used to moving or to seeing others move.

As the pace slows, the movements and even the space around and inside me seem to expand, to take on detail and fullness and life. With the passing of every month and every year, I perform the sequence more slowly. I have to in order to accommodate the growing content.

Each morning I remove myself temporarily from the frenetic timing of twentieth century America, and during the rest of the day I strive for a balance between the two ways.

The sequence teaches what many call patience. I call it attentiveness. It means giving whatever time and effort to a task that it requires to bring it full circle, to bring it to completion. It means ignoring clocks and outside pressures. It means tending to details and assuming a caring and careful approach to things and people. The lesson is to slow down, get quiet, and listen to the ways of things, yourself, and other people—to work with all these sources instead of noisily trying to control everything so that it reflects only you and the limited scope of one person's superficial consciousness.

"I wouldn't have the patience to do that," is a comment made frequently to me by visitors in my shop. Often it sounds disparaging. People like to think they're too busy to move slowly, and patience connotes slow motion—paying attention to little things when many want to think they only have time for big (important) things. People like to see themselves moving fast like the inhabitants of the TV commercials. The media tell us Americans succeed easily, grandly controlling the people and events around them. In this fast-paced culture we're conditioned to believe that faster is better. Patience, on the other hand, carries with it the possibility of impatience, frustration, obstacles that slow a person down.

Yet anyone who has ever done anything well knows patience, knows attentiveness.

I used to think I didn't have time to pay attention to certain details in my work. Now I know I have time for nothing but details, and these little things are the true substance of my work.

Noticing

In the pale light of a foggy morning I begin the sequence in my
friends' back yard. All around me a tangle of green—ferns,
wildflowers, bushes, and one looming redwood. My eye is im-
mediately drawn, as it was when I first arrived, to the orange
firecracker blossoms contrasting bright against the deep
background. Not until midway through do the few pale
lavender poor man's orchids emerge, quietly waiting, directly in
front of me.

Later I circle round to meet the silent stare of a bobcat com-
ouflaged in a row of bushes only fifteen feet away. She stands
like an Egyptian mural—body in profile, head frontal—and just
as still. She watches me slowly move; it seems a long time. Until I
turn and turn again and she is gone.

The sequence draws to the surface that part of me that notices
and in so doing unleashes all the rich and delicate detail of my
surroundings.

Wakening to details. Moving at a pace which admits them. The
journey of a thousand miles which at its end looks like magic to
onlookers is only one person attending to every step of the
making.

Magic
for the potter is in these details because they yield infinite
discovery.

I stand back, staring at a row of pitchers still glistening wet from
the throwing. I am pursuing a shape. To someone else they may
all look alike. I see the differences and try to identify why one
has life that the other lacks: the lift of a shoulder, the placement
of a curve, the thickness of a lip. Art is comprised of such
minutiae, and an artist can never allow herself to underestimate
its importance. Undetectable on a conscious level to many, I'm
convinced each detail speaks subliminally to all who encounter
the piece.

Problem solving by the indirect route

First I learned to clear my mind, then I allowed it to empty. Yet out of this silence things appear unsummoned: answers to questions, realizations, understandings. They come spontaneously during the sequence while I am not consciously grappling with any problem.

I perceive with unusual clarity while performing the movements. The perceptions often regard something very important to me, perhaps something I've been trying to understand for a long time.

Forms in clay have appeared to me—new concepts, new shapes, and new ways of using glazes. I have remembered dreams of the previous night that I thought I had forgotten, and I have grasped the meanings of dreams that until then had eluded me. Both the dream state and the Tai Chi Chuan state provide access to the subconscious, the inner self.

Which is where all the answers are.

Being centered

Tai Chi Chuan cultivates awareness and sensitivity; at the same time it builds an inner stability that helps me accommodate this growing responsiveness.

The irony of acquiring vulnerability and strength through the same exercise.

One does not exclude the other. Both exist in the whole person, must grow equally and be balanced with each other.

The sequence provides a gyroscope that maintains balance regardless of what bombards the outer shell.

Pottery breaks. This is probably the main circumstance that teaches the potter to be centered. Too many things can go wrong all along the way. The final step—the firing—is the most risky. The fragility of clay causes me to see each piece as one step in an ongoing process—to know that failure is as informative as success. The loss of a favorite piece may be sharply felt, but can only be briefly mourned. The same thing can be made again and improved on. A potter has no choice but to be accepting of disappointment and ready to try again.

A ball of clay spinning on the wheel, on center, has one unmoving part—the innermost core.

The window: opening and closing

There is a movement in the sequence called "Gracious Lady's Golden Hands". A woman goes to the window and opens it wide. I see her looking out on a vast shimmering landscape, a confusion of light, color, surface and form. Ugliness lives beside beauty and terror beside serenity. It's all there and her gaze misses nothing. She breathes it in. Then she closes the window. Inside is quiet. Stillness. A haven untouched by the tumult outside.

Tai Chi Chuan strengthens me, gives me a safe place that is always accessible. This deepset core enables me to accommodate all the noise and chaos that comes with living in the world.

I would not want to open the window if I could not close it too.

For a potter the world outside teems with pressures and influences. The pressure to produce, to make a living. The influence of current work by others praised or damned by the art establishment, of ancient work that has survived from every culture, and of the sum of the potter's life experience. It all clamors to be absorbed, sorted, incorporated or excluded.

The window opens and the window closes.

It's from behind the closed window where I talk only to myself that the choices emerge—the decisions on what can become part of my work, what cannot. My core accepts and rejects based on what resonates with it and what clashes. From this is born a coherent synthesis of me and my world that is distinctly my own work.

Skywriter

The skywriter cannot read her own message. Too close, she can only rely on her skill to shape each giant loop and slash and curve as it needs to be shaped. And then hope others at a distance find meaning in those feathery white lines against a vast blue.

The pilots over the golden beaches of Ocean City knew the content of their messages before they left the ground. They knew the vacationers below absorbing sun and sea, ice cream and soft pretzels would be watching and would comprehend.

We earthbound skywriters don't know what we will finally be saying: we can only know what has to be done at any given time. Maybe no one will be watching. Maybe no one will understand. And we ourselves are too close to see the final statement.

Following the consecutive movements of Tai Chi Chuan, I carefully form one symbol after another without an audience, not thinking how I look to others.

If people are around me, watching as I practice in the park, and I allow myself to think about how they perceive me, I become selfconscious. I falter, I waver, I lose my balance. In thinking about how I look to them, I make myself look bad. Only by staying inside myself can I create something beautiful. The message, the achievement, is in the forming itself and is oblivious to outside judgment—that of others or of myself.

My pottery teacher talked about being selfconscious and unselfconscious at the same time. This is what he meant: to know how to do something, to have acquired the wherewithal to make something with the tools and materials at hand and then to create work that is free—of other people, of oneself, of all the fears and inhibitions that limit.

An artist makes the inside of a pot, not the outside. The outside takes care of itself. Trying to produce a currently accepted look is working from the outside. Making art to win the approval of others is working from the outside. It doesn't enrich the artist or the audience.

An artist is a searcher, an experimenter, a risk-taker, drawing out or releasing feelings and bringing them into tangible form through the medium. The selfconscious and the unselfconscious work together.

An artist creates without foreseeing the final creation.

Perhaps the reason we can't see the finished statement is because it is never finished. (I see my pots as moving objects: points comprising a wave of change.) Yet there are moments without looking for it when we are far enough away and close enough to glimpse our own meaning which enfolds all meaning.

Let the road come to you

Tai Chi Chuan is easy.

Anyone can do it—it doesn't require any special strength or flexibility or talent.

Done in a state of relaxation and peaceful alertness, there's even a sensation of weightlessness when the body is on balance. Each day it blends with your body's own rhythm and pace. It is liquid.

Tai Chi Chuan should never be made difficult—be forced or done reluctantly. You don't have to pursue it—it comes to you.

Creating is easy.

Some days I set aside for play—play that goes its own way, trespasses thoughtlessly over old boundaries. Unaware and aware as a child.

Yes problems have to be solved and ways have to be found, but eagerly and in the spirit of a game.

There have to be days when I pretend the pressures don't exist. There have to be days when I don't plan, don't think about where I'm going.

I let the road come to me.

Nothing fancy

No aerobics in new pink and black striped leotards acquired with quicksilver money. No gymnastics to a rising audience. No numbers: no stopwatches, no counters. Nothing anyone else can't do, nothing to show off. Only to become.

He said he could throw fifty pounds of clay, so we all gathered round. The wheel head disappeared under a heap of clay that drooped heavily over its edges. He removed his shirt (it was a Maine summer), then wet his hands and arms for the centering, kicked the wheel hard, and lunged at the spinning mass. But he had neglected to wet his chest and all those curly blonde hairs sparkling against meticulously tanned skin grabbed on too. Fifty pounds of clay pulled him off his seat and dragged him under the wheel head. We were still laughing as he drew himself up from the flywheel, red with pain and embarrassment. Someone should have helped, but not one of us was able.

Why *Tai Chi Chuan* will never become an Olympic event

Tai Chi Chuan looks different on every person. Through the individual body the movements are translated into an individual dance. Long arms and long legs: expansive movements. Short limbs: the movements are closer in and more compact. Every difference in weight and shape contributes to a unique synthesis of body and movement. And each combination is the right one.

There is no place for competition. No race to finish sooner or later. The movements are simple and require no special athletic gifts. Each has her or his own way. The differences are to be valued and enjoyed for the interest they add to our lives—not subdued or eliminated in the false pursuit of an arbitary standard. You are your own measure.

And behind the outward variation is the inner similarity, the universality of experience arrived at from many different directions.

My work as a potter is my own work, individual to me. Every aspect of my self contributes. All my life experiences are distilled into the clay. If I altered my work to make it look like someone else's or to try to catch a juror's eye, it would not be true work. It could no longer benefit me or teach me about myself. And it would convey an empty message to my audience.

Yet, by concentrating on my own likes and dislikes, and ignoring those of others, I can paradoxically be assured of capturing some of the invisible me—which is shared with everyone else—in the visible clay. Through a single individualized product travels a nonverbal message from the shared awareness to the shared awareness. All true work is a mirror of the universal web we help to comprise.

Competition forces us to select certain qualities, exaggerate those, and disregard the others. Art and Tai Chi Chuan ask us to ignore nothing, to celebrate all diversity. The goal is not to compete but to share.

Through our differences we make contact with our similarities.

Variation: the human standard versus the standard of machines

Each day I perform the sequence a little differently. The timing of my breathing, the pace at which I move, the images I focus on, the degree of concentration or smoothness or balance: all these elements and many others vary from one day to the next.

Some mornings I decide not to do Tai Chi Chuan.

Persistence and consistence are needed. But not mechanical sameness. Within every existing thing there are infinite variables. As an expression of the dynamic force pervading everything, Tai Chi Chuan reflects this and welcomes variation.

I'm a person making things by hand in a society that worships machines. I know that people are drawn to my work as a reaction against the machines that have infiltrated their lives. Spontaneous and always changing, my work is the embodiment of an alternate ethic.

My customers often have to be reintroduced to the acceptability of variation. They have to undertand that I can anticipate results but I cannot totally control. There will always be variation —I've chosen my glazes for that very quality. Differences in a dinner set may occur from one side of a plate to the other and from one plate to the next. I show prospective customers the range of possibilities as thoroughly as I can. Dubiousness almost always gives way to intrigue. They're stimulated by the prospect of unpredictability.

The message doesn't always get across. I remember the "art patrons" who used calipers to measure dinner plates and decide which one of the nine (I had made an extra) should be eliminated from the set solely on the basis of an otherwise undetectable difference in diameter. Each plate was clearly different esthetically, but they chose not to trust their own likes or dislikes to make the selection.

Over the years I too have clashed with the fact that the finished product is not just my own, that I'm not in total control. I'm one element in a living process that also includes the clay, the glaze, and the kiln. When something doesn't come out the way I envisioned it, I've learned to ask myself before rejecting: did it come out better or worse or just different?

The danger of living in the machine age is that we may attempt to model ourselves after the machines.

Release

Behaving as if it's a force independent of the practicer, the sequence draws feelings to the surface that may not be welcome there. Sadness, anger, spiritual pain are inescapable and may be experienced intensely, especially at the beginning. Sometimes it is difficult to continue.

Tai Chi Chuan is a profound cleanser. The life energy flows through every nook and cranny of both body and soul, flushing out feelings that may have been tucked away in order to avoid. As the sequence progresses these feelings become more and more dilute. They are brought to light, acknowledged, and released.

Torn clay like unhealed wounds. Jagged edges sharp to the touch, broken surfaces unsoothed, unsmoothed by liquid glaze. these come of a certain time: peace is not there, patience is not there, a kind touch is not there.

Impressionable clay takes the imprint of my splintered spirit and reflects it back to me. Sometimes the result may be considered a success, sometimes not. But the process is always successful and always necessary. A way to a better time.

Room for everything

Tai Chi Chuan is a wide-open gate to the inner self. It screens nothing. Laughter, tears, anger, resentment, joy, exhilaration—nothing is censored.

Meeting all my responses face to face each morning through the sequence inevitably has made them not only familiar but acceptable as well. "Good", "bad", "negative", "positive" —the distinctions melt away. Each emotion is equal.

Through this experience I'm getting to know my whole self, to appreciate the largeness of my spirit and its ability to accommodate all the emotions, balance them, and build a constructive life from them.

Nothing need be ashamed of, hidden, or devalued. All emotions are to be embraced, viewed without fear and, perhaps most important, with a ready sense of humor. They teach us about ourselves and provide the sustenance on which our spirits grow.

Clay provides the same service for me, although in a more enigmatic way since my impulses are abstracted, filtered through a tangible medium with a personality of its own. And there is the added dimension of time. The first stage of the ceramic process—making things with soft clay—is very immediate. But bringing something to completion is slow and drawn out. Each pot is worked on intermittently as the stages progress. The final results frequently aren't visible until weeks after starting a piece. So it is a composite of all the different selves who worked on all the different days.

Some distance in time (perhaps even years) may be needed before the emotional origins of a style or a phase or a particular piece come clear and its layered message comprehended. It's not like Tai Chi Chuan's daily bulletins.

Clay is another gate to my interior. Through it flows all the richness, variety, and infinite depth of the entire self.

The art of doing without accomplishing

There are ninety-seven movements in the sequence Madelaine taught me. I have them listed on a sheet of paper she gives all her students to help them practice and memorize. I have been free of the list for a long time.

I start with the first and end with the last, without knowing anymore the numbers through which I pass or the time it takes me to complete them. Every morning I do the same thing, not out of a desire to accomplish something, but to experience, to enjoy, to explore.

Every morning I go from one to ninety-seven, but I had to consult Madelaine's list to remind me of this figure today.

I am a list-maker. I have always been the sort of person who likes to "get things done", "get it behind me", "get it taken care of". I list commissions and check them off; I set number goals for the pots I'm working on and the ones I plan to work on in the future. In order to make a living, to spend full time with clay, certain quantities have to be produced. So it's easy for me to become lost in numbers, to think they are most important.

In fourteen years as a potter, the clay is gradually teaching me some things:

> I don't get a pot done. It gets done when it's ready. A pot will let me know what more work it needs and when it's finished—if I will listen to it. I'm guilty of not having listened plenty of times.

> Clay cares about timing, not time. Certain processes can only be done when the clay is at just the right state of dryness, not before, not after. Damp weather slows things down. Dry weather speeds them up. I can't alter these facts, and if I try to ignore them, my work suffers.

About six years ago I got tired of concentrating on getting things done. I began to ignore some of my lists and schedules. I decided to concentrate on concentrating.

I make fewer things and throw out more things. Yet somehow I accomplish enough. What's missing in quantity is made up for in quality.

I'm breaking away from the lists, from measuring my work in numbers, and so far the numbers seem to be taking care of themselves.

Becoming all one thing

In Tai Chi Chuan every part of the body is related to every other part, every movement to every other movement, every breath to every other breath, and all of it resonates with the pool of energy that surrounds and permeates us.

The slow and rhythmic dance harmonizes our inner selves, our outer selves, and the atmosphere which is an extension of ourselves—our raw material and our source.

From the opening movement in which the palms and the entire body reach out and welcome this unbroken flow, we become all one thing.

The act of working with clay is a merging of potter and medium. An organic whole is formed as the making progresses. Potter and clay become interlaced, residing in each other even after physical separation.

The potter becomes the clay, so it is of the utmost importance that forms and textures and colors be carefully selected and their significance never underestimated.

One thing is made which is both the dancer and the dance.

My center

I know where my center is because I feel it.

Impulses originate in a place just behind my navel and penetrate outward to the rest of my body, charging everything with the unique charge of a particular response. I feel them drift upward to my brain where they can be translated into intellectual forms and expressed—sometimes gracefully, sometimes not. They don't always follow this procedure—there may be no need to communicate them intellectually or they may elude the limited powers of intellect and language. Some of them, I'm sure, go altogether undetected by my conscious level.

Through my center I am both source and receiver. From here I initiate and respond. By focusing on this part of myself, by calling on my center, I open the way to my furthest potential.

Tai Chi Chuan has helped me to know my center and uncover its power. From the first lesson, learning to breathe from the abdomen focuses attention on that area. Now, after practicing daily for six years, I recognize it as the place where all movement originates and returns. It is the hub of a wheel with arms, legs, and head as spokes. During the sequence, my "eye" is inside my belly. All else is encompassed by peripheral vision.

Because of Tai Chi Chuan my center—my true self— is gaining increased presence in my life. As it melds with more superficial layers of consciousness, everyday thoughts and activities take on new clarity and sureness. I become all one thing.

Starting from the top of an icy and wind-whipped Oregon mountain, I was a mediocre skier attempting an advanced slope. The steepness of the drop amazed me: it would not be possible to go slowly. So instead of giving all my attention to my arms and legs—the parts that appear to do the skiing—I looked to my center. This was the first time I was aware of deliberately drawing on that place—outside of meditating or performing the sequence. It balanced me, heightened my responsiveness, and revealed a competence as a skier I'd never shown before.

I relinquished control of my limbs just when I needed to be most determinedly in control. I relinquished conscious, intellectual control and switched to an unseeing, more profound and more inclusive state: all levels work in synchrony toward an agreed-upon goal with the center as catalyst and conductor.

Fear, which comes from seeing ourselves with outside eyes—either our own or others'—has to be thrown away. I had to let go of the self-conscious seeing of myself from the outside and trust to the blind yet all-knowing inside.

I imagine myself lightly touching my center, rousing it, and asking it to participate. I look forward to a time when my center will be with me always.

I have been accused
of seeing things in black and white

Tai Chi Chuan is an exercise for the invisible person who inhabits the visible one. As the body grows and strengthens with exercise, so does this inner self, this center. Over time it becomes so strong and speaks so loudly that it cannot be ignored or thwarted.

The center surfaces and intertwines with the everyday personality. Reactions to people and events take on an intensity and clarity that make it impossible to dissimulate. One's course of action is unmistakable, unavoidable, inevitable.

Choices are obvious—they seem to happen more than to be chosen. Simple—yes. Easy—perhaps not.

An artist is nothing more than a choice-maker. The medium is before her. She manipulates it in various ways. With each new shape or color or texture that appears, a response occurs within the artist which accepts or rejects, says yes or no. Keep this, throw that out, keep going, stop here. Out of these choices comes the final combination of yes's. If there has been indecision along the way, the maybe's leave their subtle, confusing traces and the piece is weakened.

Art, like Tai Chi Chuan, teaches and prepares you to react viscerally, to "know your own mind" which is much more than mind. The result is easily recognizable and very appealing. It contains its own sort of perfection, a sureness and vitality that transcends technique.

The difference

Tai Chi Chuan is a way of communicating with the self. The self is the source, the receiver, and the medium through which the message travels. It's a never-ending, spiralling process with no stopping point and no material product. The growing awareness of the practicer, a dynamic state in itself, is the result.

Although beautiful to watch, Tai Chi Chuan is not one of the performing arts. As a way of meditation it is a very private endeavor—done for my self, not for others.

I can't imagine making pottery that no one else would see. My pottery is an attempt to make contact, to communicate. On my own terms but in a language comprehensible to others.

Pottery is a product finally separate from the process, separate from the potter even. An offering from the artist to her audience. A point of stillness which can be touched and held, examined and discussed, by both.

I look for response—good and bad—and much prefer the good.

Don't believe anything you haven't taught yourself

Books are written, teachers teach, authorities emerge. It's all very interesting. But there are as many ways to do Tai Chi Chuan as there are people teaching it. The movements themselves and even fundamental concepts vary from one person to another.

Tai Chi Chuan is a continuous process of personal exploration. Statements from others are worth considering but cannot be adopted unless they happen to coincide with one's own discoveries. A person's own way, arrived at through experience, embraced and illuminated by the center, is the only true way.

I had many ceramics teachers, all with different approaches, each one ready to argue for the rightness of his or her way. I chose what I liked from each, added my own, and developed a new way.

Adopting someone else's approach which has been acclaimed and is "successful" may seem like a shortcut. Rather it's a wrong turn toward wasted time and wasted effort.

Be wary of rules.
Trust in the inner teacher.
It unfolds over time.

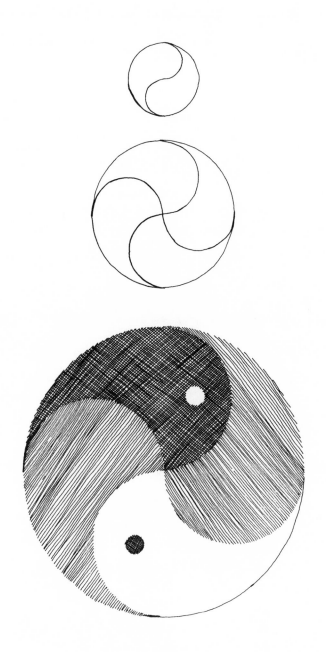